TITIAN AND HIS WORLD

This publication has been supported by
The Samuel H. Kress Foundation

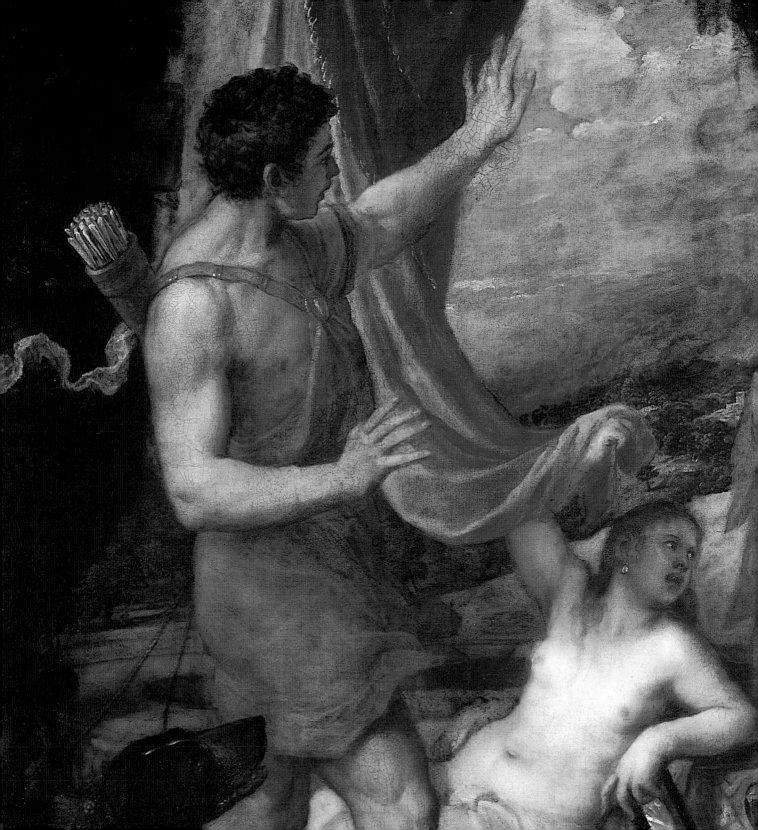

PETER HUMFREY

TITIAN AND HIS WORLD

Venetian Renaissance Art from Scottish Collections

NATIONAL GALLERIES OF SCOTLAND

EDINBURGH | 2004

Published by the Trustees of the National Galleries
of Scotland on the occasion of the exhibition *The Age of
Titian: Venetian Renaissance Art from Scottish Collections*
held at the Royal Scottish Academy Building, Edinburgh,
from 5 August to 5 December 2004.

ISBN 1 903278 60 0
Designed and typeset in Indigo by Dalrymple
Printed in Poland EU by Druk-Intro SA

Front cover: Titian *Venus Anadyomene* (detail)
National Gallery of Scotland, Edinburgh

Back cover: Titian *The Three Ages of Man* (detail)
National Gallery of Scotland, Edinburgh
(Duke of Sutherland loan)

Frontispiece: Titian *Diana and Actaeon* (detail)
National Gallery of Scotland, Edinburgh
(Duke of Sutherland loan)

The exhibition, *The Age of Titian: Venetian Renaissance Art
from Scottish Collections*, is sponsored by

Introduction

Painting in Renaissance Venice represents one of the most vital chapters in the entire history of European art. Its enormous influence on subsequent artistic developments was due above all to the achievement of its dominant personality, Titian. However, Venetian painting of the fifteenth and sixteenth centuries was extraordinarily rich in talent, and Titian's older and younger contemporaries included painters of the stature of Giovanni Bellini, Giorgione, Jacopo Bassano, Jacopo Tintoretto and Paolo Veronese. Central characteristics of the work of Titian, and of Venetian Renaissance painting in general, include a warmth and richness of colour, pronounced effects of light and shade, and bold, highly visible brushwork.

This book, published to coincide with a major exhibition organised by the National Gallery of Scotland, illustrates the work of the most important Venetian artists of the period, and traces the development of Venetian painting from about 1460 to 1615. The works included represent the main subjects and themes of the period from religious pictures to allegories, mythologies and portraits.

The book also has a Scottish theme, since all the paintings included belong, or used to belong, to Scottish collections. Some of these are public collections, while others are private, and were for the most part formed by aristocratic and other wealthy collectors during the first half of the nineteenth century.

Venice in the Renaissance

Venice in the fifteenth and sixteenth centuries was one of the largest cities in the Christian world, and the capital of an extensive empire on the Italian mainland and overseas. The city's fabulous wealth was founded on many centuries of trade with the Near East, and to safeguard the routes of their galleys the Venetians had established a chain of colonies that stretched from the Adriatic, through the islands of Greece, to the eastern Mediterranean. Similarly to protect the safe onward passage of merchandise imported from the east to the markets of Italy and northern Europe, by the early fifteenth century Venice had taken possession of most of north-eastern Italy, and even of the Lombard cities of Brescia and Bergamo, close to Milan.

This wealthy and powerful state, strategically situated at the meeting point of eastern and western civilisations, was governed by its merchant elite as a republic. The head of state was the doge, an official who was elected for life, usually at an advanced age [21]. The Venetians were intensely proud of their republican constitution, which they saw as guaranteeing a liberty and justice denied to the citizens of virtually every other state of the period. Indeed, they saw their constitution as a divine gift, bestowed on them as a people specially favoured by God.

The city itself, floating apparently miraculously on the waters of the Adriatic, a mile or two off the Italian coast, seemed the perfect embodiment of this divine favour. With canals for streets, and with no need for fortified walls or gates, it was a city unlike any other. The marble-clad palaces, the innumerable domes and campanili, the displays of luxury goods, all proclaimed not only the prosperity of its inhabitants, but also the cosmopolitanism, even exoticism of the city. As still today, the omnipresence of water endowed the buildings of Venice with a special magic, casting glittering reflections on their façades and enveloping them in a luminous haze.

Venetian painting, the history of which began long before the Renaissance period, naturally reflected the city's unique physical character and cultural traditions. Age-old contacts with the East, with the cultures of both Byzantium and Islam, stimulated the taste for material luxury and glowing colour. This is evident above all in the mosaic-encrusted interior of the state church of San Marco, which, inspired by the churches of Constantinople, in turn continued to inspire generations of Venetian painters. The watery environment of the Venetian lagoon had the complementary effect of stimulating painters to focus their attention not so much on an intellectual clarity of form and outline, as in Florence, but on surface appearances, and on sensuous and transient effects of colour, light and atmosphere.

It was one of the great achievements of Giovanni Bellini, the leading Venetian painter of the fifteenth century, to have forged an artistic style that was both fully up to date with developments elsewhere in Renaissance Italy, and true to a distinctive local tradition. In the sixteenth century Bellini's successor Titian was similarly able to maintain a dialogue

1 | Bartolomeo Vivarini c.1430–after 1491
Triptych, c.1460–70
Metropolitan Museum of Art, New York,
Robert Lehman Collection
Formerly in the collection of the Earls of Wemyss
and March

6

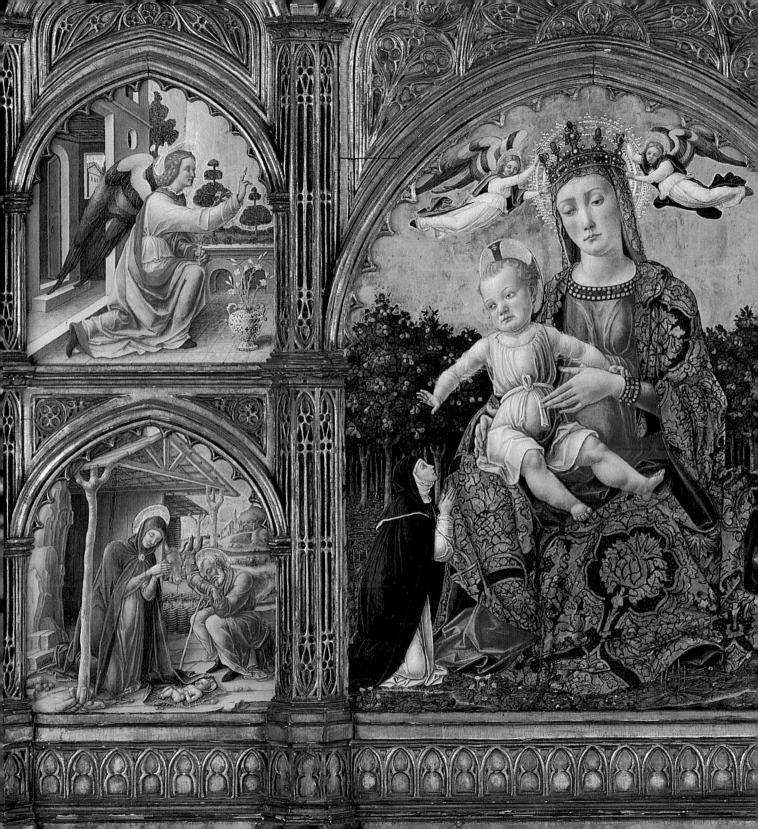

with the art of great central Italian artists such as Raphael and Michelangelo, while remaining unmistakably Venetian. By establishing a network of patrons and admirers that extended far beyond even the wide boundaries of the Venetian empire, Titian, by the time of his early maturity, had also succeeded in creating a taste for Venetian painting that had become truly international.

From Madonnas to Pastorals

The Renaissance style of painting is generally agreed to have been adopted in Venice around 1460. From about this time Venetian painters, while retaining a subject matter that was still almost exclusively religious, experimented with making their figures look more fully rounded, and with setting them into a more convincingly three-dimensional space.

Reflecting a moment of stylistic transition from the Gothic to the Renaissance is the triptych by Bartolomeo Vivarini [1], in which four smaller panels, illustrating scenes from Mary's life, surround the central image of the Virgin and Child. Kneeling to the left of the Virgin is the diminutive figure of a nun, dressed in the white robe and black cloak of the Dominican order, who presumably commissioned the work for her private devotion. Vivarini has gone to some trouble to model his forms in light and shade, and to create foreground space for them through geometric perspective. Beyond the figure group are views of distant landscape. To retain an effect of mystery and sanctity, gold is used extensively in the sky, and in the rich brocade of the Virgin's cloak. The artist appears not to be concerned with a realistic consistency of scale and the Christ Child, because of his divinity, remains oversized in relation to both the kneeling nun and the flying angels.

In the same decade, Giovanni Bellini was already beginning to express the divine in more human and naturalistic terms. Bellini was the greatest Venetian painter of the fifteenth century, and during his long career it was he, more than anyone else, who was responsible for establishing the Renaissance style in Venice. His *St Jerome in the Desert* [2] is generally recognised as his earliest surviving work, probably dating from about 1460, but it shows a landscape that is much more extensive than that of Vivarini, with much subtler lighting effects. The background serves as a

2 | Giovanni Bellini *c.*1438–1516
*St Jerome in the Desert, c.*1460
The Trustees of the Barber Institute of Fine Art, Birmingham
Formerly in the collection of the Earls of Southesk

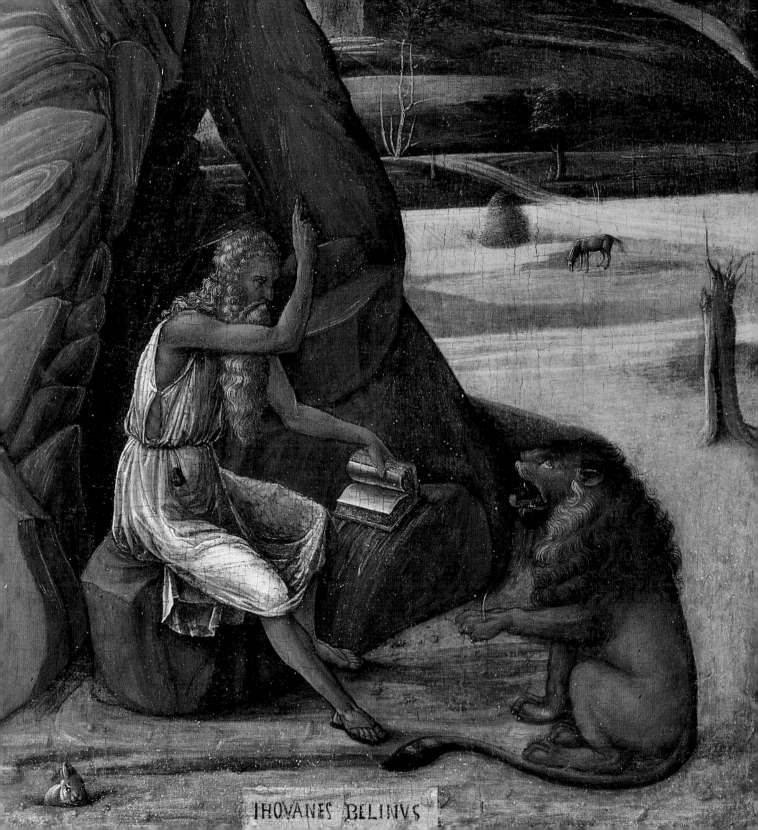

IHOVANES BELINVS

poetic commentary on the engaging scene in the foreground, in which the ascetic saint sits outside his cave and preaches to his pet lion, while the poor beast complains to him of the huge thorn stuck in his paw.

Both of these works of the 1460s were executed in the traditional Italian technique of egg tempera. By the 1470s, however, Bellini was experimenting with the Flemish technique of oil painting, which allowed the artist to achieve a greater depth and richness of colour, and a much greater subtlety of tonal modelling. His mastery of the new technique, which was to become central to the achievements of Venetian painting of the sixteenth century, is evident in *The Virgin and Child* painted about 1485–8 [3]. The theme of the Virgin and Child represented in half length behind a marble ledge was one particularly favoured by Bellini, and he painted innumerable versions of it throughout his long life. He succeeded in investing it at once with human accessibility and spiritual gravity. On one level Mary is portrayed as a mother, tenderly looking after her child as he plays with a sprig of blossom on a thread. Yet, despite the elimination of accessories such as crowns, haloes and rich fabrics, the divine status of the figures is clearly implied by their seriousness and thoughtfulness. The *Virgin and Child*, like the *St Jerome*, would have been intended for private devotion in the home, as more intimate and domestic counterparts to the large-scale sacred images that decorated the altars of Venetian churches.

The first decade of the sixteenth century was one of radical innovation in Venetian painting, in terms of content, composition, style and technique. The credit for much of this innovation is usually given to Bellini's pupil Giorgione; however, he remains a problematic figure because of the very small number of surviving pictures that we can be certain are by him. *Christ and the Adulteress* [4] depicts the gospel story in which Christ was challenged by the Pharisees to condemn a woman caught in the act of adultery. Although formerly widely considered to be by Giorgione, it is now generally held to be by another former pupil of Bellini, the young Titian. Its revolutionary character is, in any case, clearly evident when seen against the background of the artistic tradition represented by Bellini. Fifteenth-century compositions, even those with narrative subjects, tended to be calm and static. Here, by contrast, poses and gestures are bold and vehement, the figures possess a new physical robustness, and

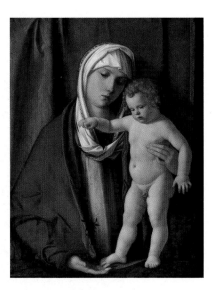

3 | Giovanni Bellini *c.*1438–1516
The Virgin and Child, *c.*1485–8
Glasgow Museums: The Burrell Collection

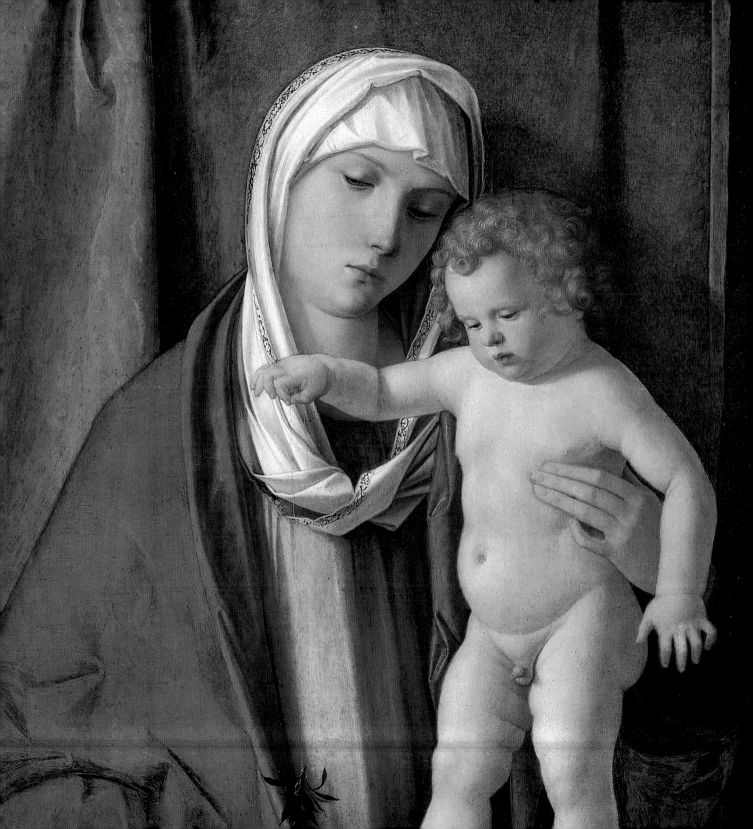

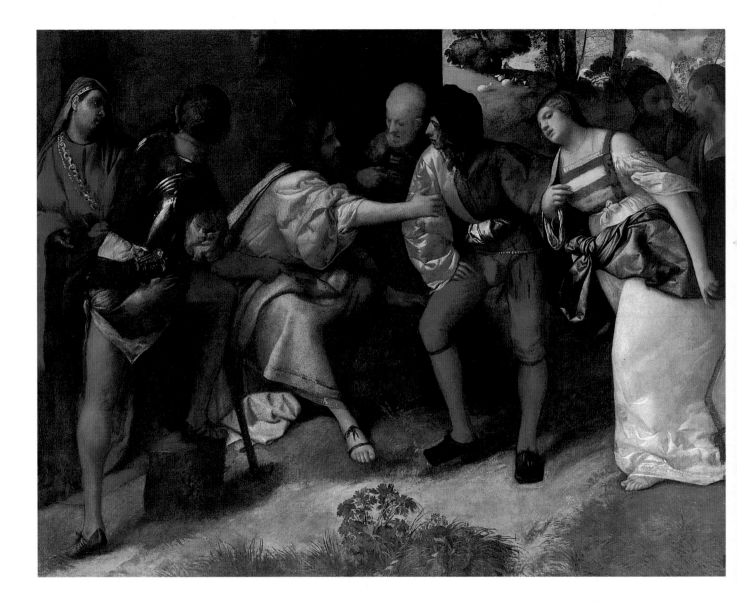

4 | Titian *c.*1485/90–1576
*Christ and the Adulteress, c.*1508–10
Glasgow Museums: Kelvingrove Art Gallery
and Museum
Formerly in the collection of Archibald McLellan

the colours of the draperies are glowingly sensuous. Whereas fifteenth-century pictures were typically painted on the smooth, glassy surface of primed and polished wood, this – like virtually all of Titian's subsequent work – is painted on the more uneven surface of canvas, and the oil paint applied with more visible brushstrokes.

Unquestionably by the young Titian, and a masterpiece from his early career, is *The Three Ages of Man* [5]. The subject is secular rather than religious, and provides a bittersweet meditation on the transience of human life and happiness. The 'three ages' of the title refer respectively to infancy, represented by the two sleeping babies watched over by a winged cupid on the right; to early maturity, represented by the lovers on the left; and to old age, represented by the old man in the central background, meditating on two skulls, which are presumably those of the lovers. The portrayal of the lovers as shepherds, feeding their passion with music in a verdant pasture, is inspired by the fashionable pastoral literature of the period, which set out not so much to tell a story as to evoke a poetic mood.

5 | Titian *c*.1485/90–1576
The Three Ages of Man, *c*.1513
National Gallery of Scotland, Edinburgh
(Duke of Sutherland loan)

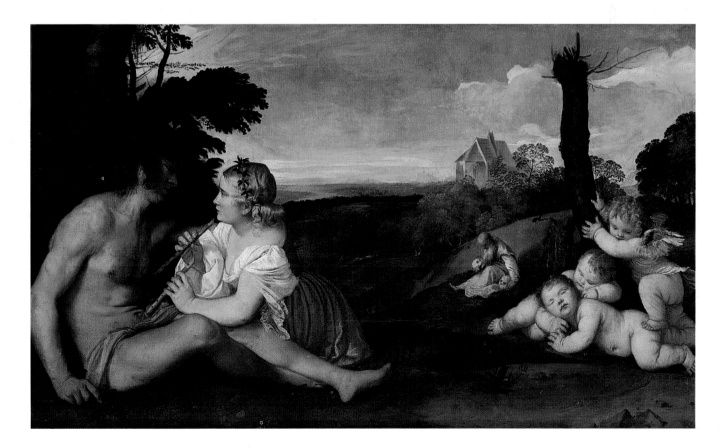

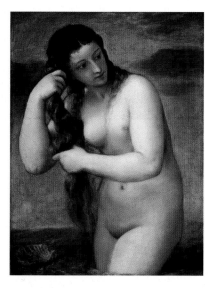

6 | Titian *c.*1485/90–1576
*Venus Anadyomene, c.*1520
National Gallery of Scotland, Edinburgh
Formerly in the collection of the Duke of Sutherland

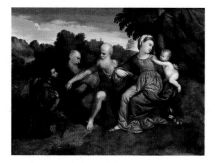

7 | Paris Bordon 1500–1571
The Virgin and Child with Sts Jerome and
*Anthony Abbot and a Donor, c.*1522
Glasgow Museums: Kelvingrove Art Gallery
and Museum
Formerly in the collection of John Graham-Gilbert

Intrinsic to Titian's greatness was not only his sumptuous use of colour but also his wide range as a painter, and he was equally successful with religious subjects and portraits as with poetic allegories such as the *The Three Ages of Man*. However, from an early date, one of the aspects of his art that was most highly prized by his patrons was his mastery of the female nude, and his ability to evoke with his brush the softness and sensuousness of flesh. The *Venus Anadyomene* [6], probably painted a few years after *The Three Ages of Man*, depicts the classical myth of the birth of the goddess of love from the foam of the sea. Titian shows her moving towards the shore, whilst wringing the water from her reddish-gold hair. The pose is adapted from that of antique statues of Venus, but any comparison with cold marble sculpture is dispelled by the play of light and shade over the figure's soft, plump flesh, and by the naturalistic flush of her face. Her face, as she emerges from the sea, is not the flawless mask of a goddess but the expressive face of a real woman, lost in thought.

The pastoral mode of *The Three Ages of Man* was also enthusiastically applied by Venetian painters to religious subjects, and one of the most popular compositional types of the second and third decades showed the Virgin and Child seated with saints in a picturesquely wooded landscape. A particularly attractive example is *The Virgin and Child with Sts Jerome and Anthony Abbot and a Donor* dating from about 1522 by a former pupil of Titian's, Paris Bordon [7]. A reference to the pastoral is retained by the detail of a shepherd with his flock in the left background, while in the foreground the original owner of the picture, dressed in a luxurious brocaded robe, is presented to the Virgin by his patron saint. In essence, the subject is the same as that of the central panel of Bartolomeo Vivarini's triptych [1] of sixty years earlier, but Vivarini's very formal and hierarchical composition has given way to a representation in which the donor is admitted to the presence of holy figures on terms of casual intimacy.

Given its small size, Bordon's picture was presumably painted for some private space in the owner's home, perhaps his bedroom. But from about the 1530s many Venetian pictures became much larger, probably because they were destined for the grander surroundings of reception rooms. This tendency is well illustrated by Jacopo Bassano's *The Adoration of the Kings* [8]. Although he is one of the greatest representatives of the Venetian

pictorial tradition, Bassano lived and worked not in Venice itself, but in the modest market town of Bassano on the Venetian mainland from which he derived his name. The painting presents a magnificent pageant as the three kings present to the newborn Child their gifts of gold, frankincense and myrrh. The painter's skill in portraying animals, unsurpassed among his contemporaries, is evident in the beautifully observed details of the ox and the ass, on the far left, and the dogs. But these, and the general bustle of the scene, are subjected to the formal order created by the semi-circular sweep of the composition, and by the decoratively repeating patches of intense colour; Bassano does not let his interest in animals and in slices of everyday life – such as the chatting boys and kneeling manservant – detract from the religious significance of the subject. The picturesque ruins on the left, for example, are certainly intended to be symbolic of the decay of pagan antiquity with the coming of Christ.

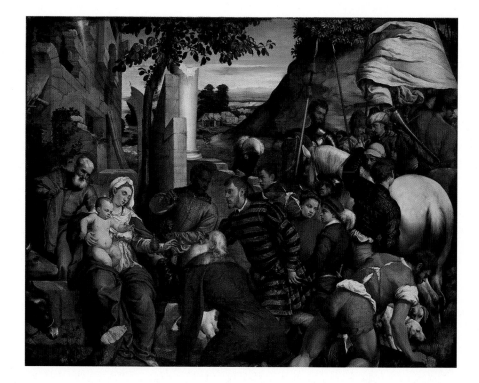

8 | Jacopo Bassano *c.*1510–1592
The Adoration of the Kings, 1542
National Gallery of Scotland, Edinburgh
Formerly in the collection of Lord Eldin

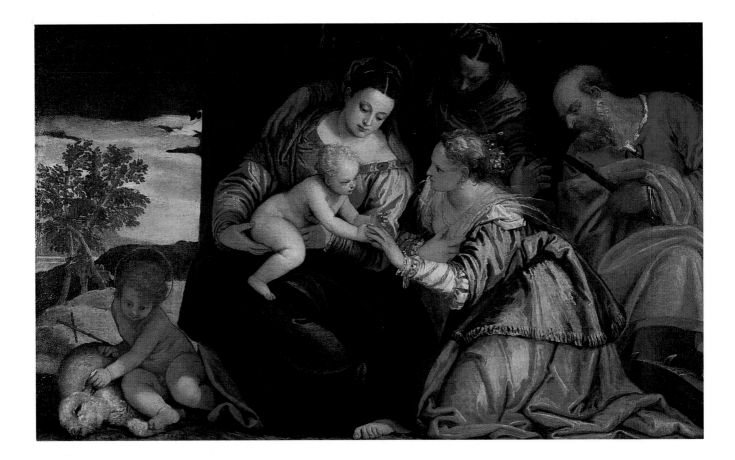

A More Troubled Age

The sunny optimism of the works by Bordon and Bassano is also to be found in the earlier works of Veronese, as in *The Mystic Marriage of St Catherine* [9]. Famous for his scenes of banquets, showing happy, healthy, richly-dressed men and women feasting against a backdrop of gleaming white architecture, *The Mystic Marriage of St Catherine* is not one of Veronese's most opulent works. Nevertheless, it shows a scene of tenderness and joy as the Christ Child, watched over by his mother Mary, his grandmother Anne and his earthly father Joseph, places a wedding ring on the finger of the princess Catherine while his little cousin, the child Baptist, plays with his attribute of a lamb. Contributing to the happy

mood are the warm and generally light colours, which are applied, as is especially evident in the figure of St Catherine, with a characteristically Venetian freedom and brilliance.

Thirty years later, however, in Veronese's *The Martyrdom and Last Communion of St Lucy* [10], the religious mood has become more serious and intense, and the colours duskier. These changes may certainly be attributed in large part to the dramatically changed religious climate of the period. In fact, the subject of the painting closely reflects two of the themes most earnestly propagated by Counter-Reformation religion: the glory of martyrdom for the true faith; and the salvation of the soul through the sacraments of the Catholic church.

The painting shows St Lucy who, refusing to give up her Christian faith, was condemned to death during the persecutions of the Emperor Diocletian at the beginning of the fourth century. In this case the work was not painted for display or devotion in a private house, but for the

10 | Paolo Veronese 1528–1588
The Martyrdom and Last Communion of St Lucy,
c.1582–8
The National Gallery of Art, Washington DC,
gift of the Morris and Gwendolyn Cafritz
Foundation and Ailsa Mellon Bruce Fund
Formerly in the collection of Sir William Forbes
of Pitsligo

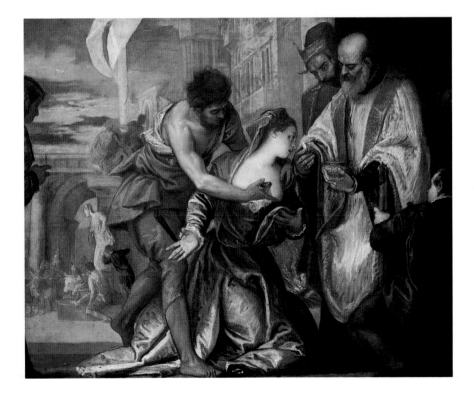

public surroundings of a church, where its religious message would have served to stimulate the piety of the faithful. The same is true of Tintoretto's *Christ Carried to the Tomb* [11], which, before its original arched top was cut off, once decorated a family altar in the Venetian church of San Francesco della Vigna. The painting shows Christ being carried to the tomb, and in the foregound, the three Maries and the Virgin, who swoons with inconsolable grief. Tintoretto was hugely prolific as a painter of large-scale canvases for Venice's churches and lay confraternities in their campaign of active spiritual renewal, and this picture shares with many of them the effects of flickering candlelight and the mood of deep religiosity.

In his later career Titian, like Veronese, developed a greater seriousness and expressive intensity, not only in his religious works, but also in his pagan mythologies. The paintings, *Diana and Actaeon* [12] and *Diana and Callisto* [13] were painted as part of a series of six large mythological canvases (or *poesie* as Titian called them) for the principal patron of his final years, King Philip II of Spain. A very general theme underlying the series is that of the loves of the Olympian gods, and of the usually tragic circumstances for any mortals who become involved with them. The principal literary source for both paintings is Ovid's *Metamorphoses*, the most popular work of classical literature in the Italian Renaissance. In *Diana and Actaeon*, the huntsman Actaeon unwittingly enters the secret glade where the goddess Diana and her nymphs are bathing by a fountain. Diana, goddess of the hunt and the moon (hence the crescent in her jewelled headdress) was also a severe guardian of chastity, and was outraged by this intrusion. As every Renaissance viewer would have known, she immediately exacted punishment by transforming Actaeon into a stag, whereupon he was chased by his own hounds and torn to pieces.

This cruel story was chosen for his patron by Titian himself, certainly in large part for the opportunities it presented for the extensive display of female nudity. In the 1550s Philip was still a young man with presumably normal sexual appetites, and the attraction of the subject was that it invited the male spectator to share Actaeon's experience by the fountain, without sharing the terrible consequences. However, the new climate of religious severity, towards which Philip actively contributed in his role as Most Catholic King, made erotic subject matter more problematic than it

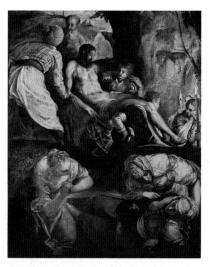

11 | Jacopo Tintoretto 1519–1594
Christ Carried to the Tomb, c.1565
National Gallery of Scotland, Edinburgh
Formerly in the collection of the Duke
of Sutherland

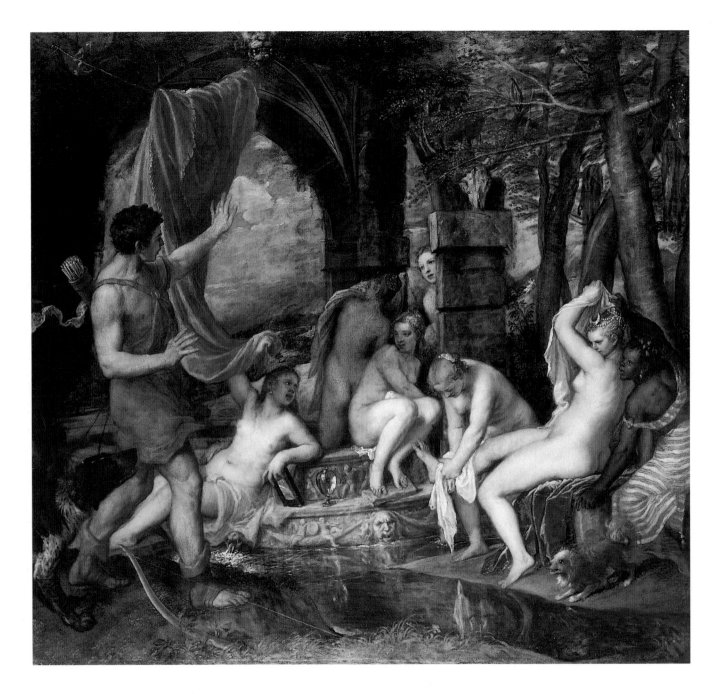

12 | Titian *c.*1485/90–1576, *Diana and Actaeon*, 1556–9
National Gallery of Scotland, Edinburgh (Duke of Sutherland loan)

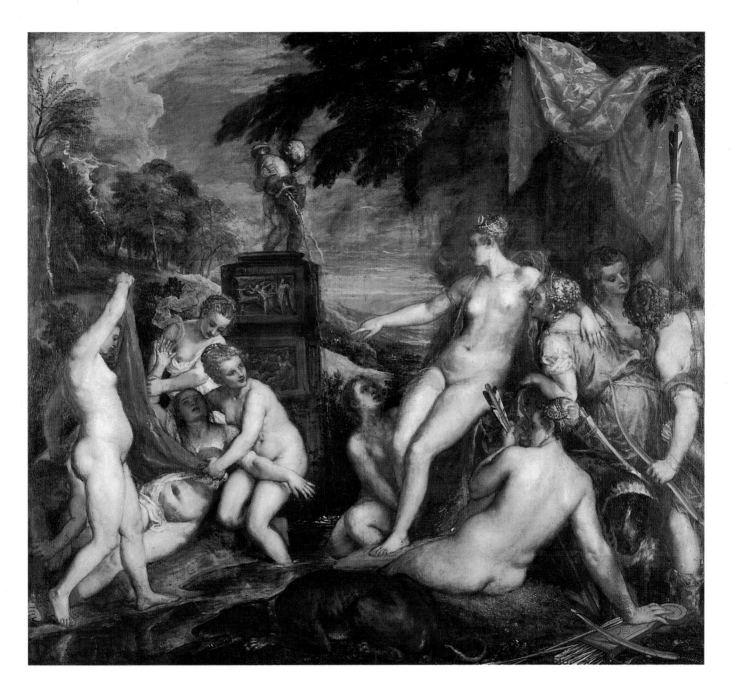

13 | Titian *c.*1485/90–1576, *Diana and Callisto*, 1556–9
National Gallery of Scotland, Edinburgh (Duke of Sutherland loan)

had been when Titian painted the *Venus Anadyomene* forty years earlier. The *Diana and Actaeon*, together with the exactly contemporary *Diana and Callisto*, are obviously much darker in mood and more tragic in their implications. In the latter work, the unfortunate Callisto, who had been seduced by Jupiter, is shown being stripped by her companions at the command of the chaste goddess Diana to reveal her pregnancy. Banished for her shameful state, Callisto was transformed into a bear by Jupiter's jealous wife Juno, but was later immortalised by him as the constellation of the Great Bear.

At this late stage of his career Titian's brushwork has also become much looser and more choppy than in earlier works such as the *Venus Anadyomene*. This freedom of handling, if not Titian's tragic vision of human destiny, is shared by Andrea Schiavone's *Infancy of Jupiter* [14], a work apparently executed in about 1560. The direct impact of the *Diana and Actaeon* is evident in the picturesquely rusticated classical architecture on the left background, and especially in the descending chain of mountains on the right. In the left foreground, the infant Jupiter is shown with three nymphs and the goat Amalthea, to whom he was entrusted by his mother to protect him from his child-eating father Cronus. The wild Curetes, whose noise helped save the infant by drowning his cries, are interpreted by the painter as musicians playing Renaissance *viole da gambas* and a recorder. Despite his lack of interest in anatomical accuracy, Schiavone succeeds in investing his composition with great rhythmical fluency.

14 | Andrea Schiavone *c.*1515–1563
*The Infancy of Jupiter, c.*1560
Collection of the Earl of Wemyss and March KT

Portraiture

In 1460 the art of portraiture hardly existed in Venice, with the exception of the full-length portraits of donors that were sometimes found in religious subjects. For example, the figure of the nun in Vivarini's *Triptych* [1] probably provides a more or less accurate portrayal of the person who commissioned the work. Bust-length profile portraits of the Venetian head of state, the doge, also existed at an early date. But portraits do not become common in Venetian painting until the 1490s when Bellini began to paint them in greater numbers. Thereafter, Venetian portraiture developed rapidly in scale and in compositional and emotional range, and by the 1530s Titian had become the most sought-after portrait painter in all Italy, and perhaps Europe.

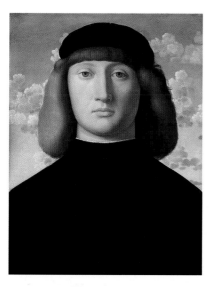

15 | Vicenzo Catena *c.*1470/80–1531
Portrait of a Young Man, *c.*1505–10
National Gallery, London
Formerly in the collection of the Dukes of Hamilton

Early Venetian portraiture is well illustrated by the *Portrait of a Young Man* by Vincenzo Catena [15]. Characteristic of the tradition of portraiture established by Catena's master Bellini is the bust-length format with a blue-sky background. The painting shows the sitter in the austere, formal dress of Venice's governing class with just a hint of luxury provided by the fur lining that peeps out from under his black robe. The sitter's features are described with delicate precision, and are made to appear convincingly three-dimensional through careful modelling in light and shade. The rigid symmetry of the composition lends the sitter a certain dignity, but it precludes any effect of movement. The scale is smaller than life, and the picture is painted on wood, with smooth, virtually invisible brushstrokes.

In portraiture, as in other areas of painting, the tradition established by Bellini was transformed in the first decade of the sixteenth century by Giorgione. In contrast to the reserved formality of most fifteenth-century portraits, Giorgione introduced a new quality of soulfulness and intimacy into portraiture. He also expanded its expressive range by introducing motifs and compositional devices associated with other types of picture, so that in some cases it becomes difficult to decide whether or not a portrait-like image is meant to represent a real person. His younger contemporaries continued to explore the possibilities that he opened up for portraiture and related images for at least a decade after his death.

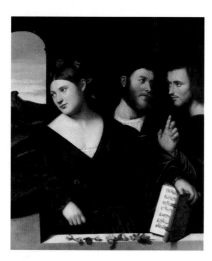

16 | Bernardino Licinio *c.*1490–*c.*1549
Allegory of Love, *c.*1520
Koelliker Collection, Milan
Formerly in the collection of the Barons Kinnaird

Bernardino Licinio's *Allegory of Love* [16], for example, appears at first

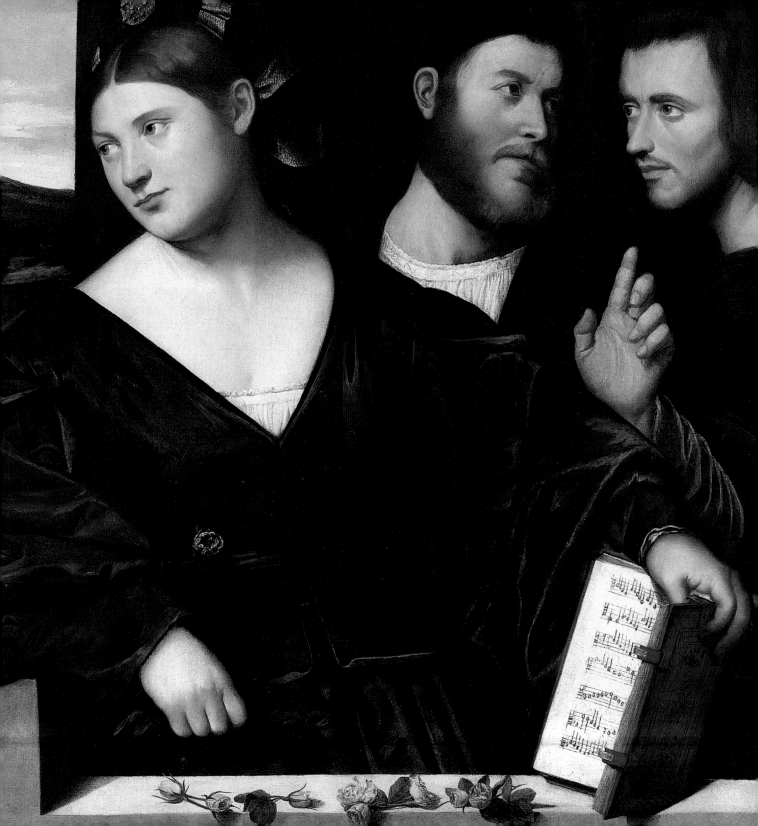

sight to be a triple portrait. The features are very natural, and the figures wear fashionable contemporary dress. But other elements make it likely that they were meant to be interpreted allegorically, and not as recognisable people. In particular, the prominent way in which roses are displayed on the ledge in the foreground and in the woman's belt clearly allude to the sweetness but transience of love. Nor can this be a simple scene of everyday music making, since the musical score is for an instrument, yet the figures represented are not instrumentalists. Instead, music is invoked, as in Titian's closely contemporary *The Three Ages of Man* [5], as another poignant symbol of the transience of beauty and happiness.

Equally packed with symbolism, but this time certainly representing the portrait of a real woman, is the magnificent *Portrait of a Lady as Lucretia* by Lorenzo Lotto [17]. Resplendent in a dress of orange and green striped silk trimmed with squirrel fur, and ostentatiously displaying a gold necklace with an exceedingly luxurious jewelled pendant, the sitter gestures towards a drawing of the ancient Roman heroine Lucretia. A virtuous married woman, Lucretia was raped by the son of the tyrannical King Tarquin and, rather than bear this dishonour to herself and her husband, committed suicide with a dagger. The Latin quotation on the slip of paper, prominently placed on the table, is taken from the classic account of the story by the Roman historian Livy. Lotto's sitter, whose own name was presumably Lucrezia, thereby identifies the Roman heroine, a wife who valued her chastity above life itself, as her role model.

Lotto's achievement in this visually sumptuous and highly expressive work is astonishing considering how comparatively rare female portraits were in Venetian painting at this time. Lotto was also a pioneer in the use of the horizontal, as opposed to the more natural vertical format for portraiture. Here it provides room for the table (on the right) with its display of references to Lucretia's story, and especially for the expansiveness of the sitter's gesture. Her active, knee-length pose is, while somewhat stilted, highly expressive, and her sharp outward gaze is similarly effective in drawing the attention of the spectator to her message.

Although Lotto enjoyed considerable success as a portraitist during his residence in Venice between 1525 and 1533, he could not seriously compete in this field with Titian. More than any other sixteenth-century

17 | Lorenzo Lotto *c.*1480–1556/7
*Portrait of a Lady as Lucretia, c.*1533
National Gallery, London
Formerly in the collections of Sir William Forbes
of Pitsligo and the Earls of Southesk

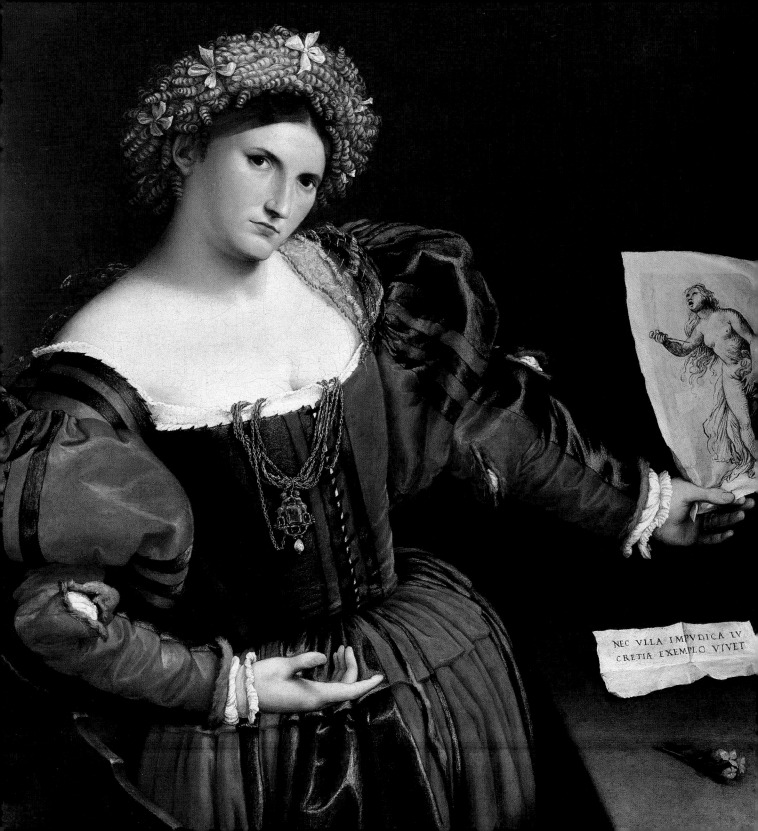

NEC VLLA IMPVDICA LV
CRETIA EXEMPLO VIVET

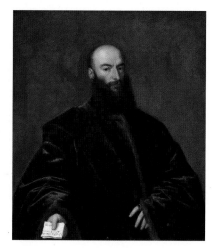

18 | Titian *c.*1485/90–1576
*Portrait of Jacopo (Giacomo) Dolfin, c.*1530–5
Los Angeles County Museum of Art, gift of the
Ahmanson Foundation
Formerly in the collection of James Ewing,
Strathleven

Venetian painter, Titian understood how to meet the needs of the ruling
classes by combining the demands of likeness with those of social dignity
and emotional reserve. Titian's *Portrait of Jacopo (Giacomo) Dolfin* [18] –
perhaps commissioned to commemorate the sitter's appointment as
provincial governor of the mainland city of Treviso in 1532 – shows him
dressed in his sombrely opulent official crimson robes, and displaying an
identifying letter with a simple gesture of his right hand. His severe and
somewhat inscrutable facial expression is appropriate to a nobleman
appointed to weighty responsibility.

Inevitably influenced by the example of Titian, yet making quite a
distinctive contribution to their genre, were the portraits by Giovanni
Battista Moroni, a painter working in the town of Bergamo on the west-
ern fringe of Venice's mainland empire. One of this finest is the *Portrait of
Don Gabriel de la Cueva, later Duke of Alburquerque* [19], in which the pose of
the Spanish nobleman – soon to become governor of the nearby city of
Milan – is lent grandeur by the abstract geometry of the architectural foil
behind him. Moroni's handling of paint is thinner and drier than that of
Titian, and parts of the costume are rendered with an attention to detail
that by this date had become foreign to the pictorial tradition of Venice
itself.

Compared with the official portraiture of an earlier generation,
Titian's portrait is endowed with a new effect of physical presence and
with a new grandeur of scale. In these respects it was the model for later
portraits of Venetian noblemen and office-holders, as in Tintoretto's
Portrait of a Procurator of St Mark's [20]. In its composition, this portrait
looks back to Titian's portraits of robed dignitaries such as Jacopo Dolfin,
while expanding further the length and the scale. Now showing the sitter
majestically enthroned, Tintoretto's portrait anticipates the imposing
portrait of the Venetian head of state, *Doge Marcantonio Memmo* (reigned
1612–15), here attributed to Jacopo Bassano's son Leandro [21]. By this
date, however, forty years after Titian's death, the great age of Venetian
painting had passed away.

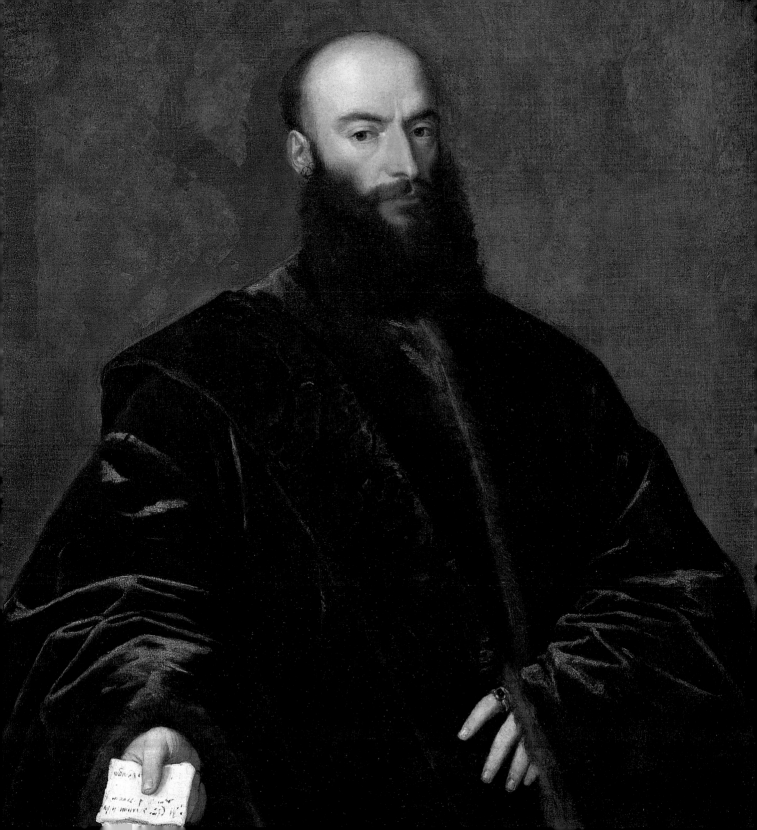

Venetian Painting and Scotland

19 | Giovanni Battista Moroni 1520/4–1578
Don Gabriel de la Cueva, later Duke of
Alburquerque, 1560
Staatliche Museen zu Berlin, Gemäldegalerie
Formerly in the collection of Sir William Forbes
of Pitsligo

The decline of Venetian painting at the beginning of the seventeenth century coincided with an enormous increase of interest in the great sixteenth-century masters among art collectors all over Europe. Prominent among these were King Charles I of England and Scotland (reigned 1625–49), and his leading courtier James Hamilton, 1st Duke of Hamilton (1606–1649). Around 1637, Hamilton, whose brother-in-law happened to be the English ambassador to Venice, bought three important collections of Venetian pictures, and had them shipped to his house in London. On the outbreak of the Civil War in 1642, Hamilton had his works of art packed into crates to be sent for safe keeping to his Scottish seat of Hamilton Palace, near Glasgow. However, they never reached their destination, and after his execution in 1649, shortly before that of his royal master, Charles 1, they were sold off by parliament. Most of Hamilton's pictures now belong to the Kunsthistorisches Museum in Vienna.

The Venetian school, and the work of Titian in particular, continued to be highly admired by collectors, connoisseurs and artists throughout the seventeenth and eighteenth centuries. But relatively few new examples reached London in the century and a half after the fall of Charles I, and hardly any reached Scotland. All this was to change, however, after the French Revolution of 1789, and especially during the peace following the Battle of Waterloo of 1815. The dramatic political and social upheavals in France and Italy during this period released vast numbers of paintings on to the London art market. And the wealthy classes throughout Britain, whose investment in art had often previously been restricted to family portraits, were ideally placed to begin forming extensive collections of European art.

The rediscovery of Scotland by the wealthy and educated classes in the earlier part of the nineteenth century, and its improved accessibility from the south, also meant that the Anglo-Scottish nobility were now inclined to spend more of their time at their ancestral seats instead of in London. They also filled their rebuilt and refurbished country houses with Italian, including Venetian, old master paintings. By far the greatest Scottish collection of the nineteenth century was that formed by Alexander

AQVI ESTO SIN TEMO
Y DELA MVERTE

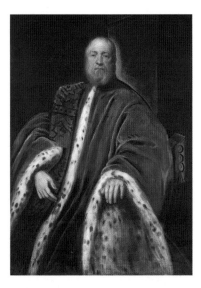

20 | Jacopo Tintoretto 1519–1594
Portrait of a Procurator of St Mark's, *c.*1580–3
The National Gallery of Art, Washington DC,
Samuel Kress Collection
Formerly in the collection of the Earl of Wemyss
and March KT

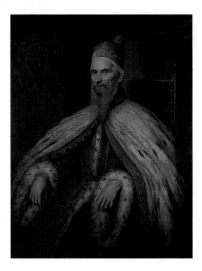

21 | Attributed to Leandro Bassano 1557–1622
Doge Marcantonio Memmo, *c.*1612–15
From the collection of Hopetoun House,
South Queensferry

Hamilton, 10th Duke of Hamilton (a direct descendant of the 1st Duke) at Hamilton Palace. Rebuilt by him on a massive scale, the palace contained pictures by (or attributed to) all of the great Venetian masters of the sixteenth century. Other prominent collectors of the time included the 4th Earl of Aberdeen (one of Queen Victoria's prime ministers), the 4th and 5th Earls of Hopetoun, the 8th Baron Kinnaird, Sir William Forbes of Pitsligo, and Lord Elcho (later 10th Earl of Wemyss). Less typical was the wealthy Glasgow coachbuilder Archibald McLellan who, unlike his aristocratic counterparts, bequeathed his collection to his native city, creating the nucleus of a new civic art gallery. From about the middle years of the century, the taste for Titian and his contemporaries began to expand to include the previously neglected Primitives, or masters of the fourteenth and fifteenth centuries. A number of Scottish collectors, including the portrait painter John Graham-Gilbert of Glasgow, the 9th Earl of Southesk, and again Lord Elcho, began to buy works by Giovanni Bellini and his contemporaries.

In 1882, however, virtually the entire contents of Hamilton Palace were sold by auction in London, and in the 1920 the house itself was demolished. These developments were symptomatic of a general decline in the power and wealth of the landed aristocracy, and towards the end of the nineteenth century the private collecting of old masters went into rapid decline. With the partial exception of the shipping magnate Sir William Burrell, whose purchase of Bellini's *The Virgin and Child* [3] in 1936 fell well outside his usual area of taste, no important new private Scottish collectors emerged in the twentieth century. In partial compensation for the paintings lost to Scotland through sales and dispersals, the National Gallery of Scotland's collection has gradually grown in quantity and quality. An especially important development was represented by the loan to the Gallery in 1945 by the 5th Earl of Ellesmere (later 6th Duke of Sutherland) of twenty-six paintings of outstanding quality. Of the eight Venetian pictures in the Sutherland loan, three – by Lorenzo Lotto, Tintoretto [11], and most recently Titian [6] – have passed during the intervening period into the ownership of the Gallery. In the half-century since the war Edinburgh has become, in fact, a site of world importance for the viewing and enjoyment of Venetian painting.

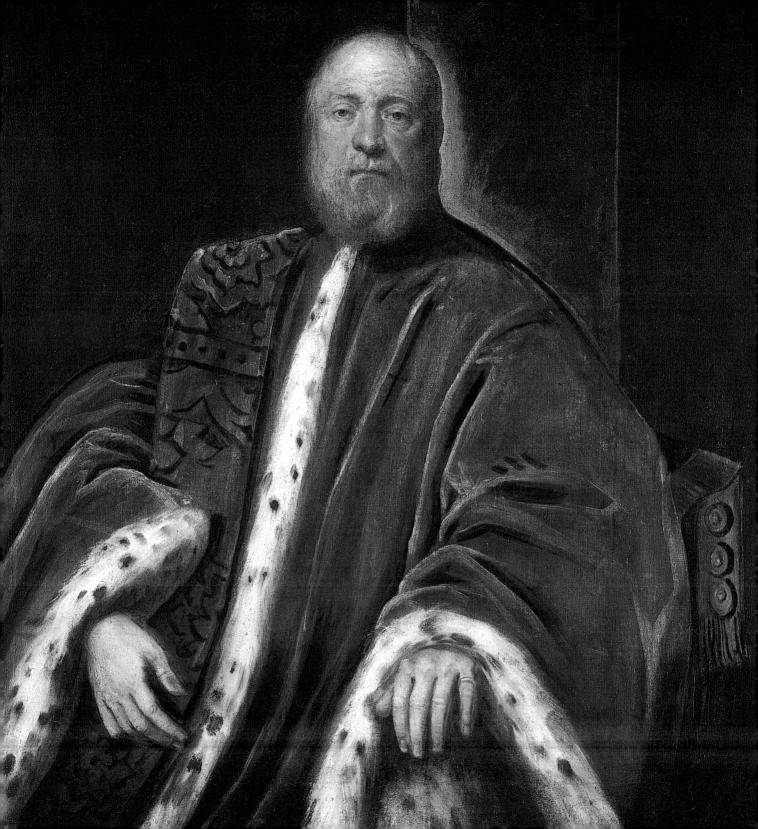

The Age of Titian

If you have enjoyed this book
and would like more information,
the catalogue which accompanies
the exhibition is available from:

NGS Publishing
Dean Gallery · Belford Road
Edinburgh EH4 3DS

www.nationalgalleries.org

Photographic material has been supplied
by the lenders unless otherwise specified.

© Jörg P. Anders / bpk: 19
© Bridgeman Art Library: 2
© Keith Hunter Photography: 9
© 2004 Museum Associates / LACMA: 18
© Jack Mackenzie (AIC Photographic
Services Ltd): 6, 14, 21
© Antonia Reeve: 5, 8, 11, 12, 13